Natalie Fobes

I DREAM
A·L·A·S·K·A

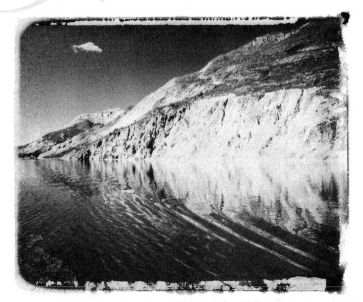

NATALIE FOBES

ALASKA NORTHWEST BOOKS™

Anchorage · Seattle · Portland

To my partner and love, Scott Sunde. And to the many Alaskans who opened their homes, camps, boats, and hearts to me over the years. I thank you.

Acknowledgments

From my first journey north to the one that ended last month, I've depended on the kindness of the Alaska stranger. I've lived with fishermen in boats and biologists in tents, with families at fish camps, and with trappers in cabins. These are the people I believe in. These are the people I trust.

For more than a decade, Richard Murphy, Mike Campbell, and Bonnie Bernholz have given me refuge from my often stormy life.

Debbie Apatiki, LeRoy Kulukhon, Allen Kulukhon, Larry Merculieff, Nick Krukoff, Rick Knecht, Debbie Amarok, Winton Weyapuk, Sumner Merculieff, Keaton and Colleen Gildersleeve, Gary Thill, Slim Huckeby, Bill Cutsforth, Ben Thompson, Swede Ecklund, Gail Evanoff, the Fliris family, Brad Larsen, Jimmy Schmit, Pete Blackwell, Dale Gorman, Kurt van Brero, and Bob Mauck trusted me to tell their stories.

Mark and Mary Emery, Al Grillo, Roy Corral, Anna Kertulla, Jim Jager, Erik Hill, Fran Durner, Paul Souders, Mary McCafferty, Mark Kelley, Charles Mason, Dale Anderson, Jim Magdanz, Phil Borges, Julee Geier, Scott Freeman, and Mark Daughhetee have inspired me.

Oil spill veterans Rick Steiner, David Grimes, Jack Lamb, Torie Baker, Barbara Holian, George Capacci, Jay Laub, and Al Kegler have continued to be my allies.

Biologists Jim Harvey, Bob Nelson, Cathy Frost, Jim Sedinger, Tom Fondell, John Gissberg, and Barry Grand have helped me understand.

Katie McCullough has helped me discover the joy of Polaroid™ transfers, Bob Weaver has kept my business going when I was away, and the board of Blue Earth Alliance has encouraged me in my work.

My thanks to Gary Settle, who gave me my first assignment in Alaska; to Chuck Kleeschulte, who lent me his parka in the dead of winter; and to Susan Gilmore who stood in the door of the plane, preventing it from taking off until I finished my business in Dutch.

My gratitude to my brave editors Marlene Blessing and Ellen Wheat, my determined agent and friend Elizabeth Wales, and creative designer Betty Watson, who once again pulled it all together.

Great memories, my friends. This book is for you.

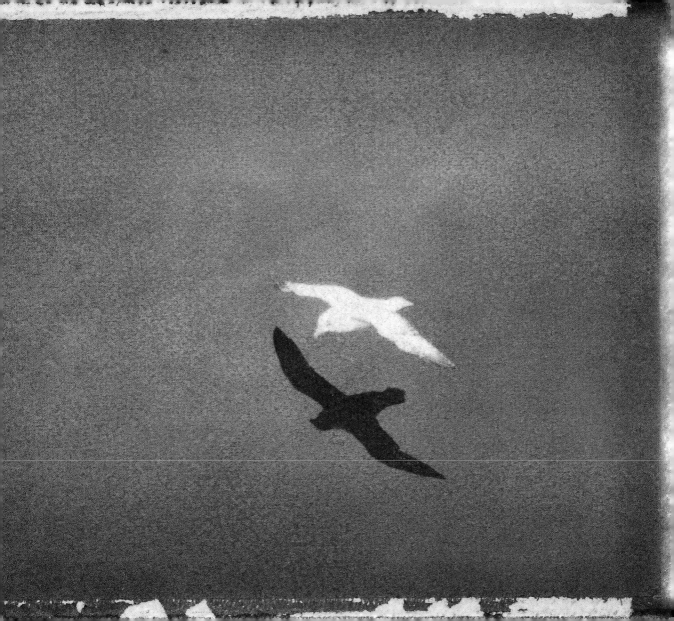

About the art of the Polaroid™ print technique

Natalie Fobes chose the Polaroid™ transfer process to print the photographs in this book.
To achieve the technique, a Polaroid™ photograph is taken of a slide. Before the print has a chance to
fully develop, the negative is pulled from the Polaroid™ film pack and laid on a sheet of paper.
The dyes transfer to the paper, creating an image with a timeless, dreamy quality.
It was this effect that Natalie wished to achieve in *I Dream Alaska*.

Text and photographs copyright © 1998
by Natalie Fobes

Editors: Marlene Blessing and Ellen Harkins Wheat
Designer: Elizabeth Watson

Front cover and page 1: The land and the sea merge in
Glacier Bay National Park. *Page 3:* Gliding gracefully
over the water, a northern fulmar looks for food in the
Bering Sea. *Page 4:* Injured when he flew into a power
line, Volta preens himself at the Alaska Raptor
Rehabilitation Center in Sitka. *Back cover:* Detail of a
cedar totem pole from Ketchikan's Totem Bight Park.

Fobes, Natalie, 1954-
 I dream Alaska / Natalie Fobes.
 p. cm.
 ISBN 0-88240-501-2
 1. Alaska—Pictorial works. 2. Alaska—
Description and travel. I. Title
F 905.F63 1998
979.8—dc21 97-32930
 CIP

Alaska Northwest Books™
An imprint of Graphic Arts Center Publishing Company
P.O. Box 10306
Portland, OR 97296-0306
800-452-3032

Printed on acid-free and chlorine-free paper in Singapore

Contents

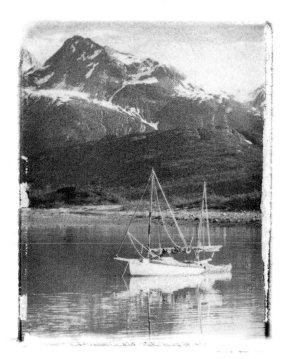

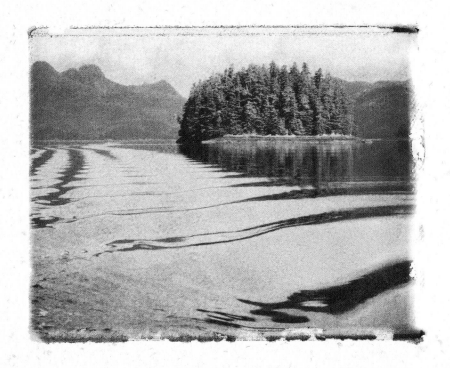

Close your eyes and inhale the heavy salmon-flavored air. Hear the bald eagles laugh their jagged call. Listen carefully as the sea's thin ice tinkles like cubes in crystal glasses. Alaska will resonate in your memory long after you are gone.

I can hear Alaska calling from a thousand miles away. In Alaska the air is fresher, the sky wider, the mountains more spectacular, the sea more breathtaking, and the wildlife more awesome than anywhere else I've been. And just when I think I've seen it all, a humpback whale glides beneath our boat. He has turned so he can catch a glimpse of the creatures called humans that hang over the rail.

But Alaska is more than a picture postcard. Alaska can be ruthless and unforgiving to those who are not wary. Her seas will crash down on you and steal your body, her winters will suck the breath from your lungs and take your fingers, her vastness will test your sense and spirit and soul to see if you really can be by yourself.

Tragedy first summoned me to Alaska. Two crab boats had capsized near the small Aleutian Islands port of Dutch Harbor. I was assigned to cover the story. These were the days at the end of the king crab boom, when almost everyone passing through

◄ Land and sea join in the bays of Alaska.

7

Dutch was a fisherman, a processor, a hooker, or a lawyer.

As we were landing, the plane came in sideways, buffeted by the curlicue winds rolling down from the mountain that rises at the end of the tarmac. More than once on that descent I wondered what I'd gotten into. But within an hour of landing I was in the wheelhouse of a crab boat with an Aleut fisherman I didn't know, eating beefsteak seasoned with the oil from a harbor seal. The first of my grand Alaska adventures had begun.

I've had many in the last fifteen years and taken photographs that chronicle each journey. My favorites are not necessarily the familiar views of Alaska, but rather are of friends and places where I've felt at home. They remind me that each trip has been a pilgrimage. Each one has been a lesson. Alaska has strict rules, you see. Rules you must obey.

These rules are simple on the surface, a blend of wild and civilized savvy. Bears have the right-of-way. Moose do too. Look

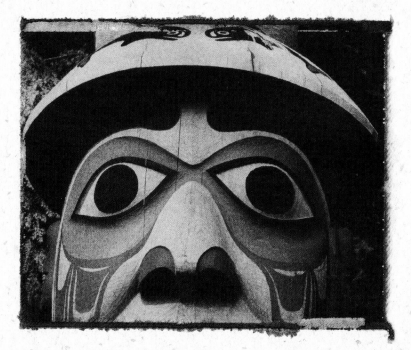

where you step. Know where you are. Keep mosquito repellent in your pocket at all times. Know where your knife is. Don't stand in the middle of a coiled rope on a boat. Don't piss off the bush pilot. Bring more than enough food when you head to the bush, and don't keep it in your tent. Carry two sets of mittens.

◀ Native artists carve their families' stories on cedar totem poles. Replicas of ancient poles are found in Ketchikan's Totem Bight Park.

▶ His face bearing the scars of an Arctic life, LeRoy Kulukhon hunts for bowhead whales.

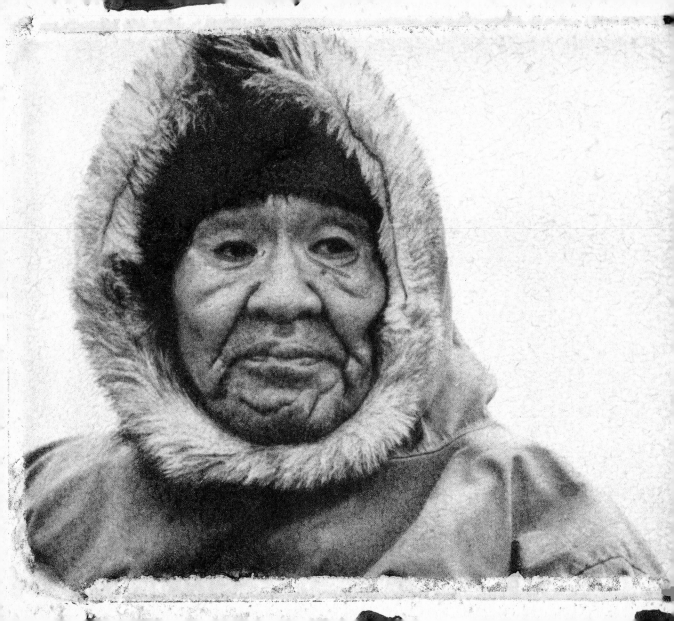

Let silence fill in the edges of conversations. Don't ask anyone if he is wanted in the Lower Forty-eight. Keep your trail clean. Stop at traffic lights when you are in Anchorage. Have a return airplane ticket. Trust your instincts.

Your conscience opens to ancient messages when you live on the edge of Alaska's wildness. Spend a few days in your tent waiting out a storm: The world shrinks to a four-foot shelter of mostly wet nylon. Scuffles outside the tent break the drumbeat of rain and wind. Curious creature or hungry beast, friend or foe, your mind reviews each breath-catching possibility.

These are the kinds of days, Eyak Indian elders say, when people who have passed on before come back to watch over you. They stay behind the clouds that are tethered to mountain ridges, Marie Smith Jones told me. They hide so they won't frighten us with their faces. When in Alaska, I can believe that spirits come alive to take the form of animals and trees and rocks.

Marie Smith Jones is the last full-blooded Eyak Indian.

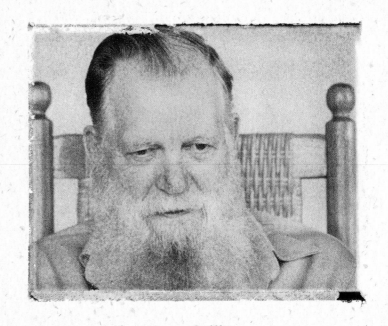

An old-timer enjoys the sitting porch of the Pioneers' Home in Sitka, Alaska.

On the Kobuk River, the auburn tundra burns into my eyes and shadows creep long across the foot-high blueberry bushes. A yellow-leaved willow ten yards from my hillock quivers. A caribou emerges and eyes me with annoyance, interloper that I am. Camouflaged by sunset, he's been watching me watch the scene.

In the Pribilof Islands, I awake from a vivid dream full of promise, foreboding, and shadows. In my dream a delicately colored salmon smolt eases from my cheek. In the warmth of my bed, with another Bering Sea storm blasting the windows, I wonder about the significance of this nocturnal vision. The next morning, an Aleut villager I meet asks about my dream. *The special dream,* he says, *the one you had last night.* How did he know?

On the Yukon-Kuskokwim Delta, I see a vertical line shimmering in the heat waves that reflect off the marshes. The hair on my neck stands up, my heart beats quickly; my body tells me I should flee. Yes, I know it is the biologist who is doing a pintail duck survey a mile away. But ancient memories remain from a time when a form on the horizon meant danger. Ancient memories brought back to life in this old, new land.

On bright days, I often stand at the boat's railing and look down at the sea. A fulmar slow-dances with the waves, its shadow waltzing with the emerald water. Through a law of physics I have never understood, the sun halos my body. Shafts of light radiate from my head and disappear into the depths of the sea. When I raise my eyes, I realize I am just one small, insignificant part of creation.

Do the kittiwakes soaring overhead even note my passing? Do the eyes of the wolf follow my form across the beach? How long will my scent linger in the rounded pebbles after I'm gone?

I look to the mist-shrouded mountains. Sitka spruce stand like lonely sentinels in the clouds. Here I am far from the cities, from so-called civilization, and yet I am not alone. The wonder and hopes, and despair too, of all who have made the Alaskan journey are in the wind's embrace. I can feel them. I can feel their touch. In my heart, in my soul, and deep within my Alaska dreams.

▶ Clouds caress the mountains in Misty Fiords National Monument.

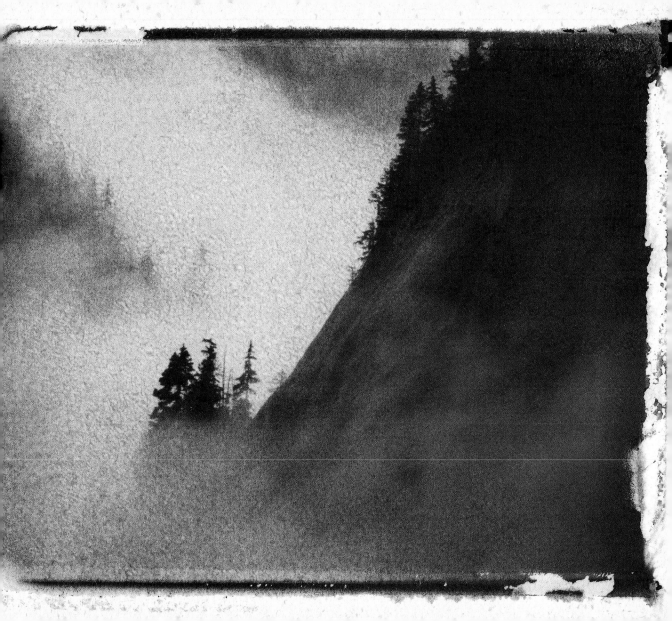

Arrivals

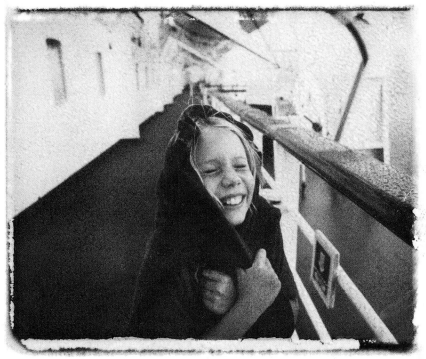

Her face covered with raindrops from a Southeast downpour, Katy Couleur laughs during a cruise to Alaska. Each year, over a half-million passengers journey to Alaska by cruise ship.

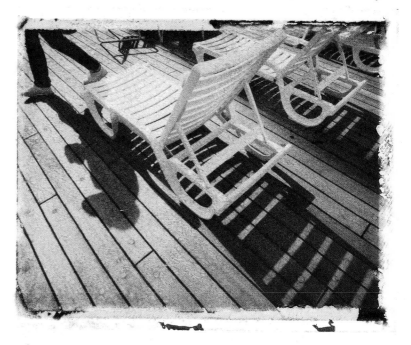

Lounge chairs line the promenade deck of an
Alaska-bound cruise ship.

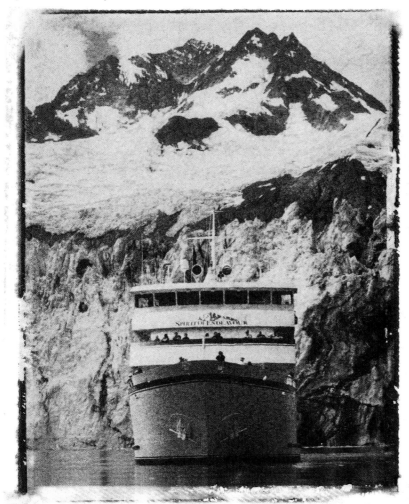

With the Johns Hopkins Glacier behind it, the 100-passenger M/V Spirit of Endeavor cruises through Glacier Bay.

Lost in reverie during a visit to Misty Fiords National Monument, Theresa Siebert watches the mountains play hide-and-seek with the clouds.

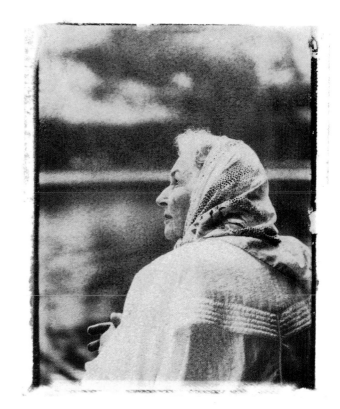

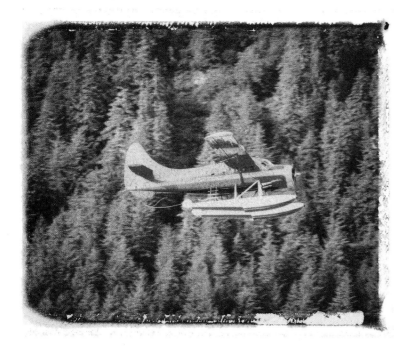

Floatplanes are to Alaskans what automobiles are to commuters. The only way in or out of the more remote areas of Alaska is by plane.

Despite Ketchikan's reputation as a rain-sodden town, residents joke that they see the sun at least a dozen times a year.

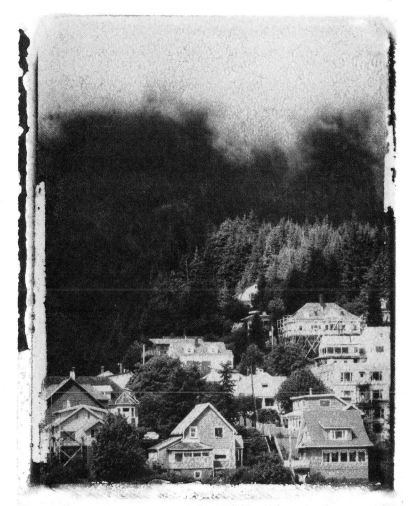

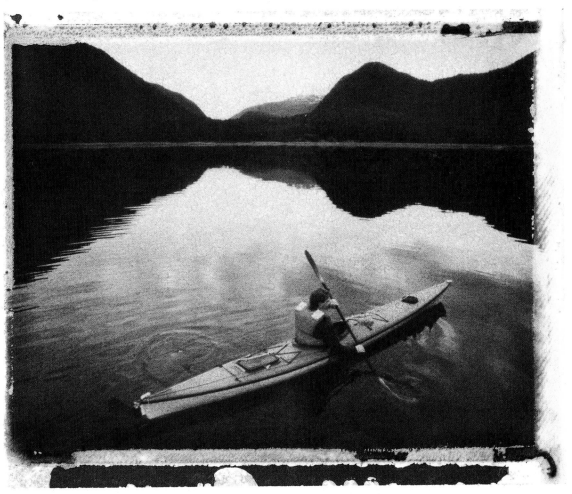

◄ Kayaker Scott Pope explores a bay in the Tongass National Forest.

► Unofficial Petersburg ambassador and longtime commercial fisherman Syd Wright enjoys taking tourists out in his fishing boat for a taste of the Alaskan life

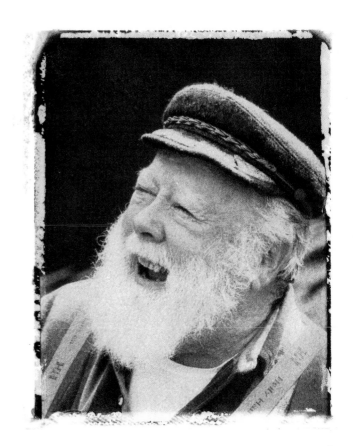

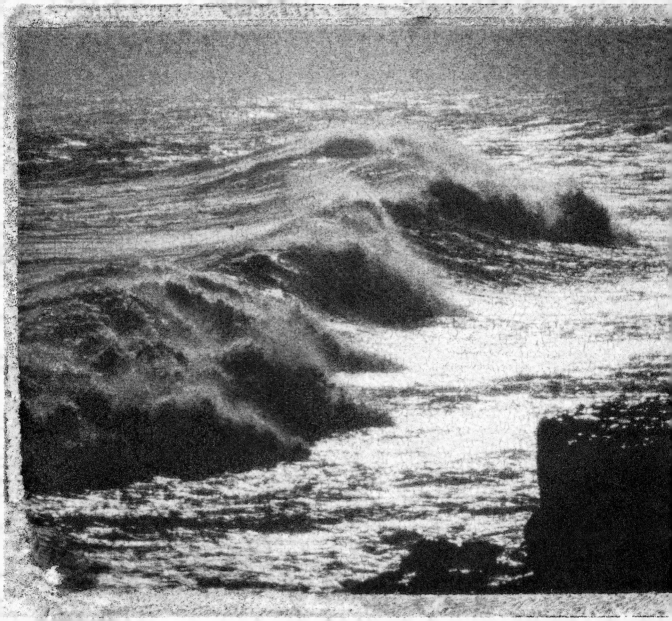

Sea

Spawned by winter
winds blowing over
80 knots, waves crash
to shore in the
Pribilof Islands.

With a wind-powered
roar, the sea races to shore
beneath the cliffs of the
Pribilof Islands. The
fertile green depths of
Alaskan seas nurture a
myriad of creatures,
from salmon and seal,
crab and krill, to whales,
foxes, and birds.

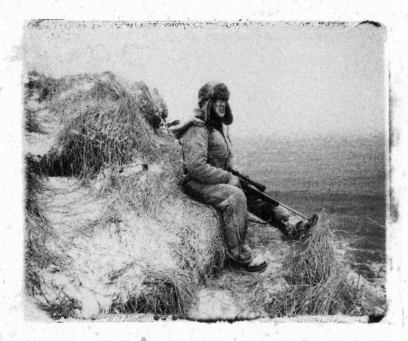

◄ Hunter Ambrose Galanin watches for sea lions near the Aleut community of St. Paul in the Pribilof Islands. His ancestors were seafaring hunters who traveled the Bering Sea in baidarkas, the forerunner of modern kayaks.

Pribilofs

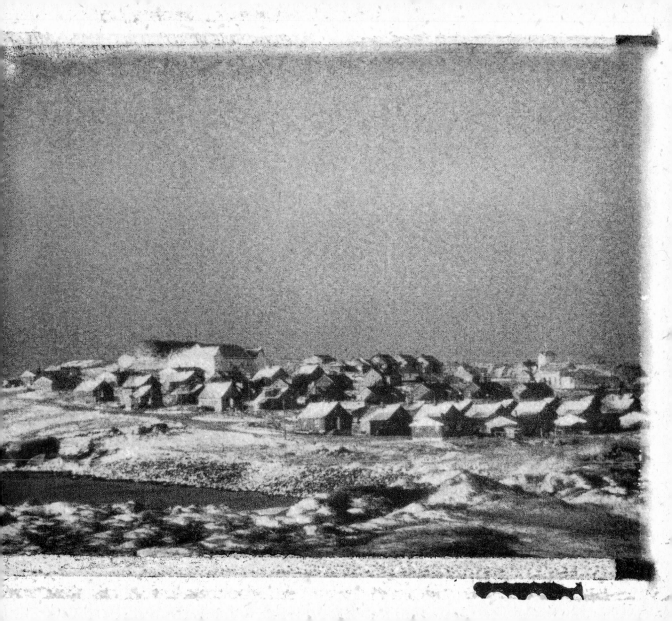

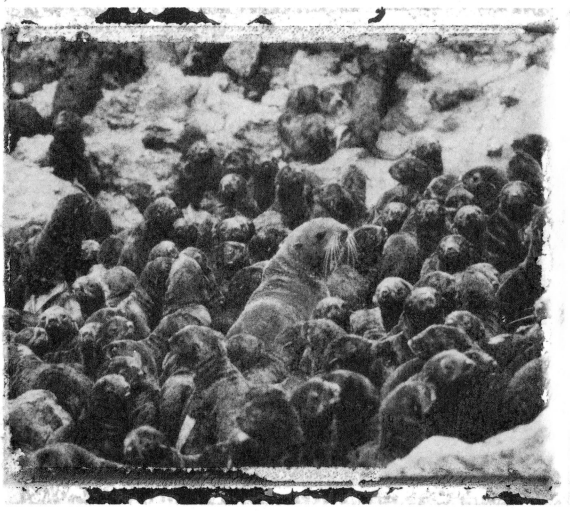

◄◄ Winter's evening sun highlights the village of St. Paul.

◄ Surrounded by pups, a fur seal searches for her own at a rookery on the island. Ninety percent of the world's northern fur seal population breeds in the Pribilofs.

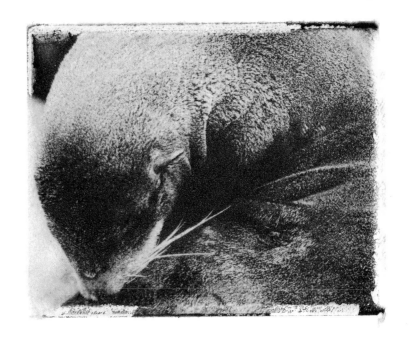

▲ A fur seal preens herself on St. Paul, one of the two largest Pribilof Islands. In the early 1800s, Russian fur traders forced Aleut hunters to the islands to be closer to the valuable creature.

Sea

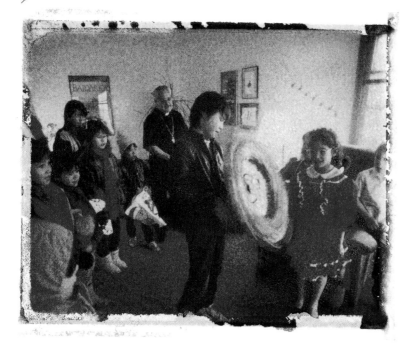

▶ Winter winds and snow have stripped the paint from wooden crosses in the Russian Orthodox cemetery on St. Paul Island.

▲ In a Russian Orthodox tradition that dates back centuries, children twirl the Christmas star and sing carols to St. Paul's priest, Father Michael Lestenkof. While possession of Alaska was transferred from Russia to the United States in 1867, the Russian legacy continues in the religion and cultures of many coastal peoples.

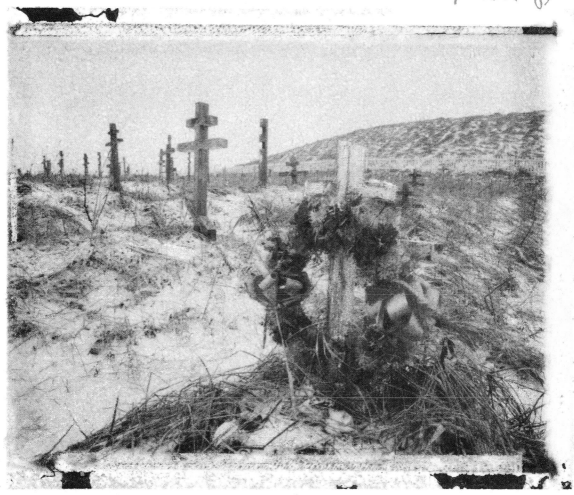

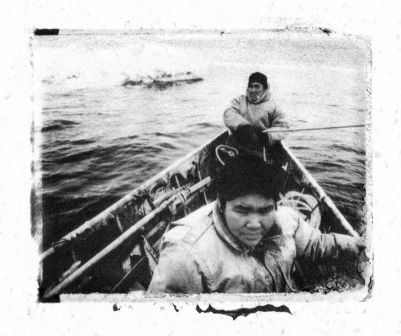

In an ancient tradition, Siberian Yup'ik from St. Lawrence Island hunt for bowhead whales in sail-powered skin boats. Russia's mainland is closer to the island than Alaska's.

Gambell

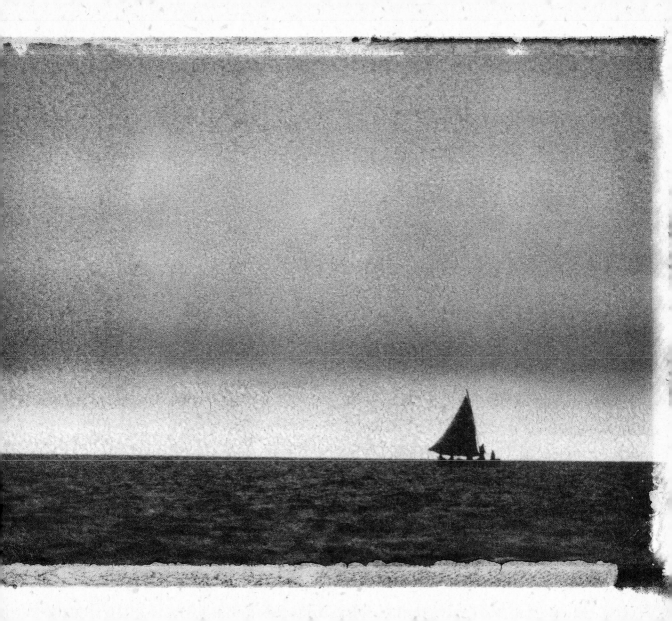

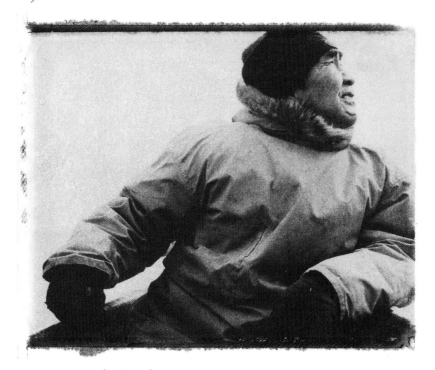

▶ Dragging their walrus skin boat across the shore ice, Siberian Yup'ik whale hunters return to the village after an unsuccessful outing.

▲ Hunter LeRoy Kulukhon looks for bowhead whales. If successful in killing a whale, the hunters will divide the meat among all families in the village.

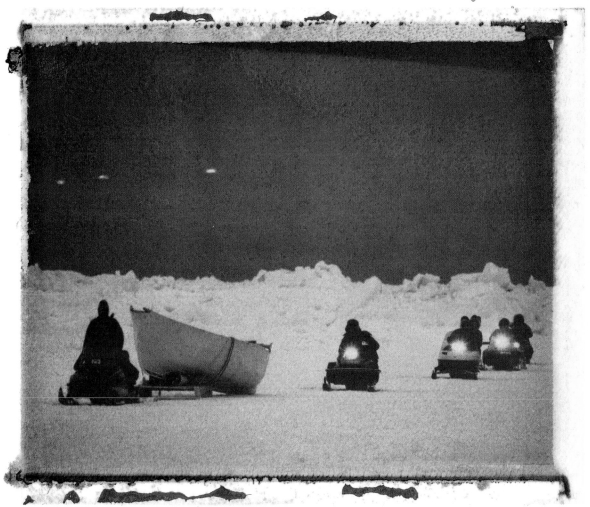

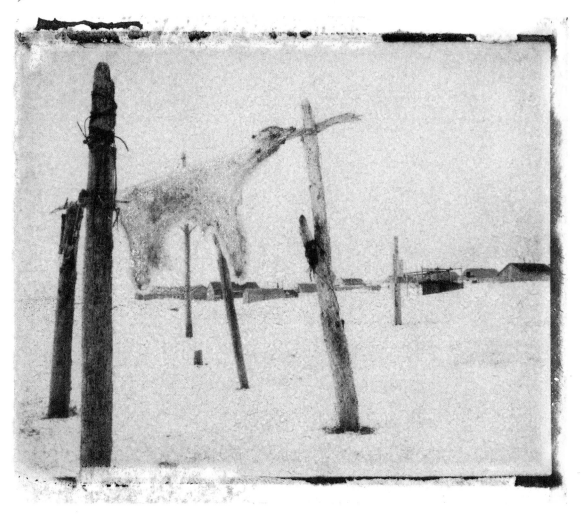

▼ Debbie Apatiki guides her son Miles home during a May blizzard. Winters are long and summers short on this island in the middle of the Bering Sea.

◄ A polar bear made a fatal mistake when he ambled into the village one evening. Now his skin dries on a rack outside the hunter's house on St. Lawrence Island.

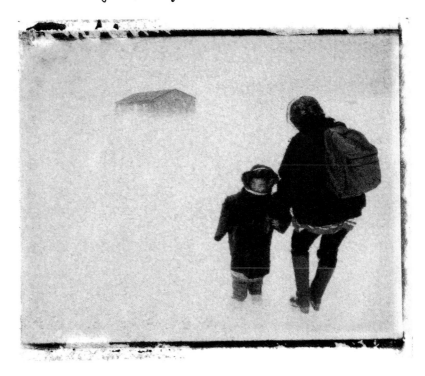

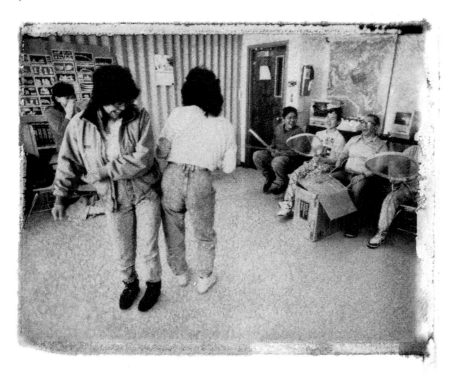

Traditional Siberian Yup'ik dancing is taught at Gambell High School. Dances and songs are handed down from generation to generation, with performances the highlight of long winter nights.

Two-thirds of the graduating class prepare for commencement exercises. Few graduates leave the island after high school.

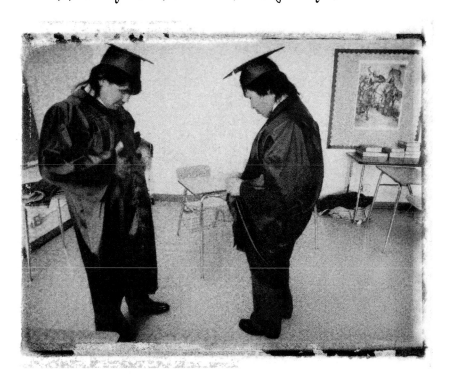

Sea

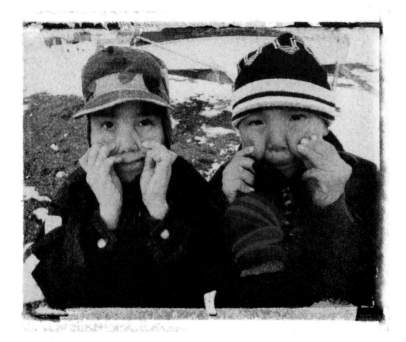

▲ Bored with watching adults talk, kids make funny faces for a visitor to Gambell.

▶ With a wolverine ruff and goose-down snowsuit, Lorianne Roonooka keeps warm as her parents launch a walrus skin boat. In a tradition that continues today, villagers hunt bowhead whale and walrus.

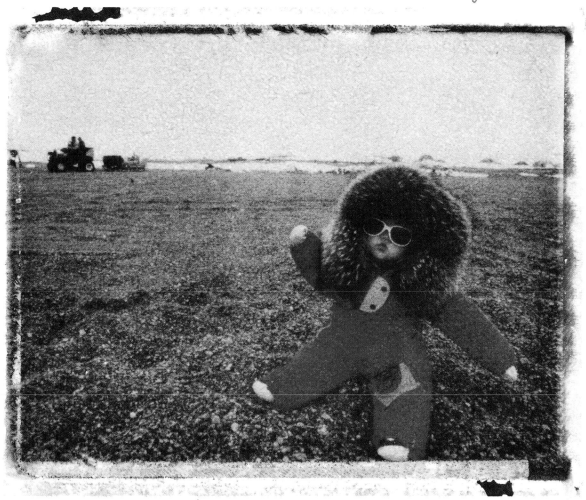

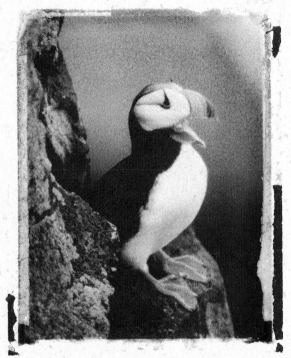

◄ A tufted puffin calls to its mate from a cliff on the Pribilof Islands. With rookeries of puffins, murres, kittiwakes, and other seabirds, the remote islands are known as a birder's paradise.

Sea Creatures

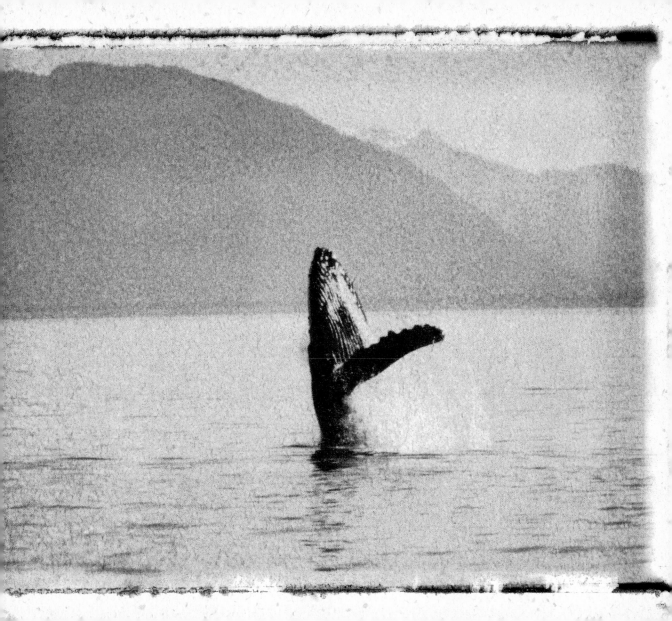

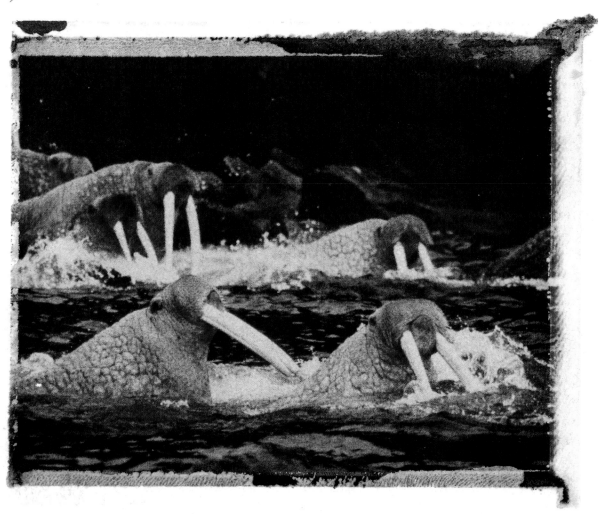

▶ A whale louse crawls out of his barnacle-lined home in the skin of a gray whale.

◀◀ A humpback whale blasts from the waters of Frederick Sound. Each year hundreds of humpbacks journey from Hawaii to Southeast Alaska to feast on the area's abundant krill and herring.

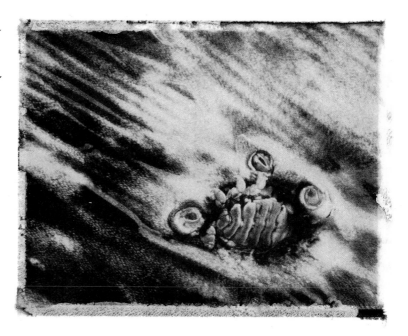

◀ Male walrus swim in a bay near Round Island. In the summer thousands of males feed, fight, and hang out, waiting for the females to join them.

▲ The tail and hind flippers of a walrus are all that show as he dives off Round Island in the Walrus Islands State Game Sanctuary.

► Victims of overhunting, only twenty northern elephant seals were alive in 1892. But the largest of all seals has made a comeback, thanks to conservation efforts and protective laws. Their range today extends from the Baja Peninsula to the Gulf of Alaska.

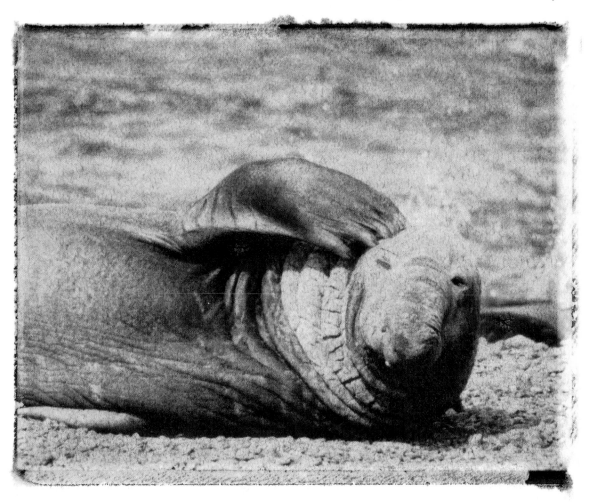

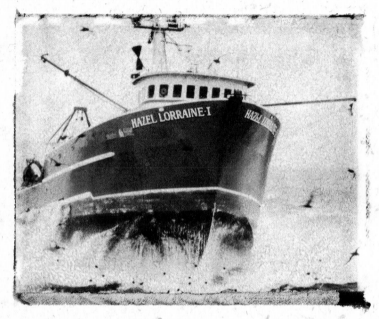

◄ Waves toss a fishing boat from the sea. Fishermen consider the Bering Sea one of the roughest bodies of water in the world, but its abundance of fish draws men and women willing to take the risks along with the rewards.

Fishing

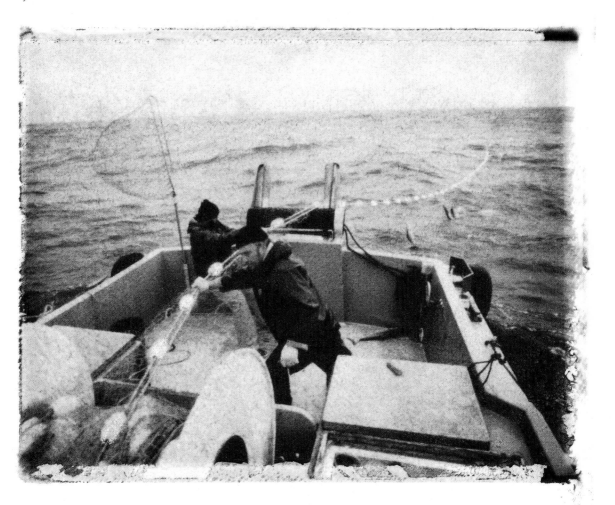

◄◄ Caught in nets that hold up to 120 tons of fish, walleye pollock are prepared as fillets and surimi.

◄ Jimmy Schmit and Pete Blackwell pull in a salmon gill net in Bristol Bay. The Bay is home to the world's largest salmon return, and also supports the largest commercial salmon fishery.

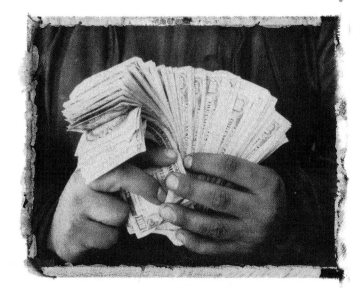

▲ A Bristol Bay fisherman holds $21,000 he made for nine days of work in 1988. Fishing is risky though, and some years fishers lose their shirts, like in 1997 when only half the expected number of salmon returned to Bristol Bay.

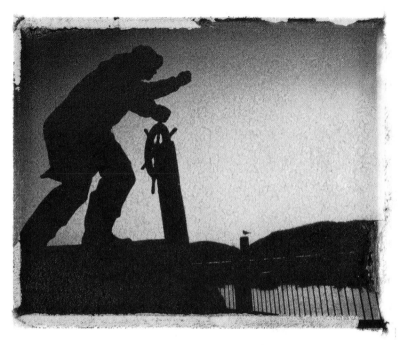

Superstition and fishing go hand in hand. Some say it was folly to erect this statue at the Cordova docks depicting a fisherman cursing the sea. Shortly after it was finished, the supertanker Exxon Valdez ran aground in Prince William Sound.

Continuing a long-standing tradition, Bristol Bay fisherman Pete Blackwell kisses the first salmon of the season before releasing it back into the water. Old-timers say this will bring the fishermen good luck.

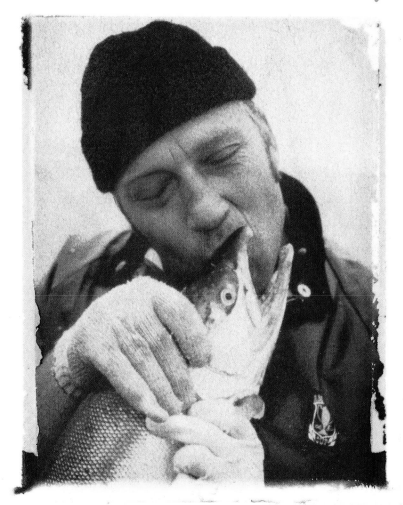

Sea

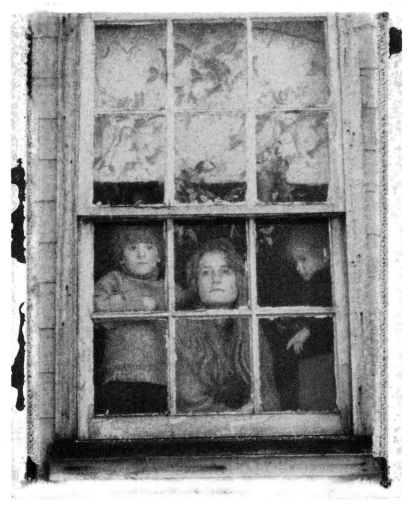

◄ Perched on a hill above Dutch Harbor, Susie Sielicki and her children watch for her husband's crab boat.

► For a couple hours around midnight, and if fishing is slow, Bristol Bay becomes almost tranquil as fishers grab some sleep.

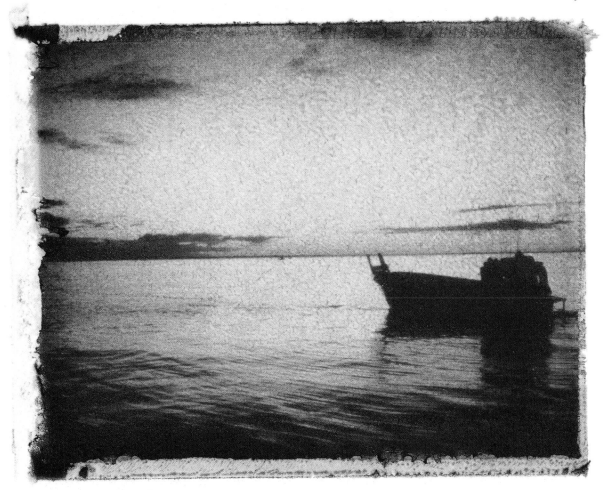

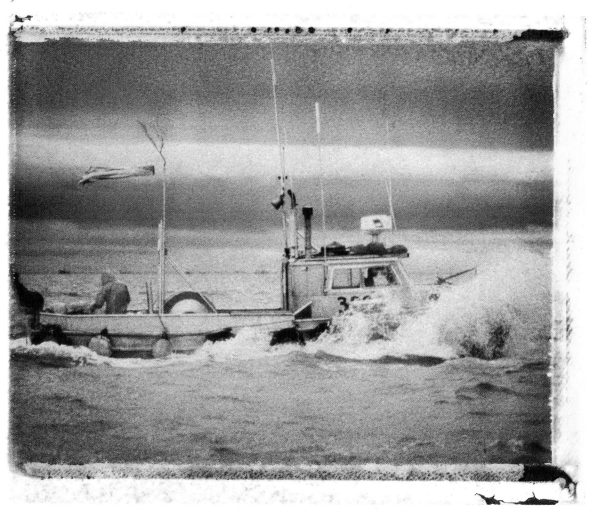

▼ With long hours, tedious work, and grand adventures behind them, cannery workers say good-bye after a season on a fish processing slime line near Kenai in Cook Inlet.

◀ A boat loaded with thousands of pounds of salmon rides low in the water after a fishing opener in Bristol Bay.

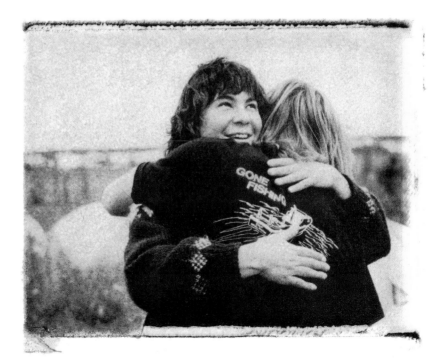

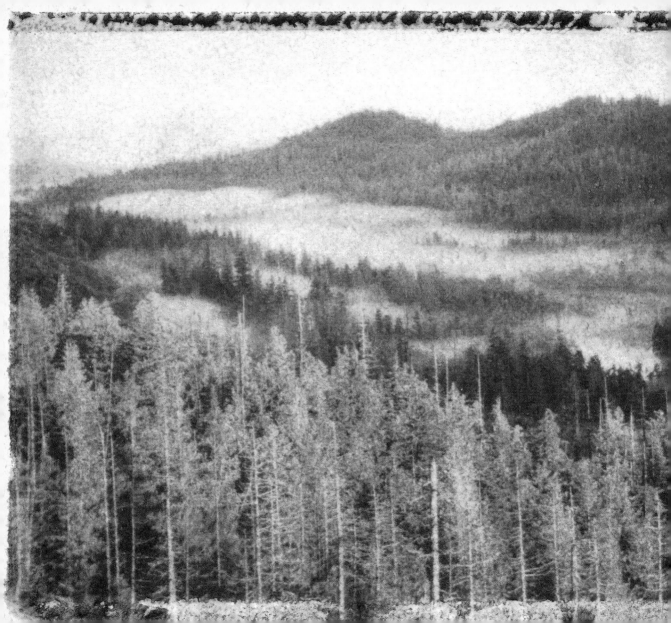

Land

Lush forests of
old-growth cedar,
hemlock, and spruce
stand on Sealaska
Native Corporation
land in the Tongass
National Forest.

Mountains and tundra, forests
and rivers; amber-cloaked
aspens, lichens, and ice.
Alaska's symphony of
landscapes offers a wildness
and diversity that sustain
human and beast alike.

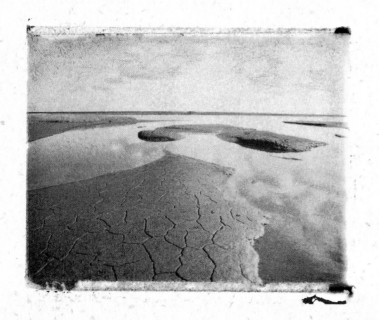

◄ Mud channels lace the flats of the Yukon-Kuskokwim Delta at low tide. The mud can suck the boots right off of the feet of the unwary visitor.

Tundra

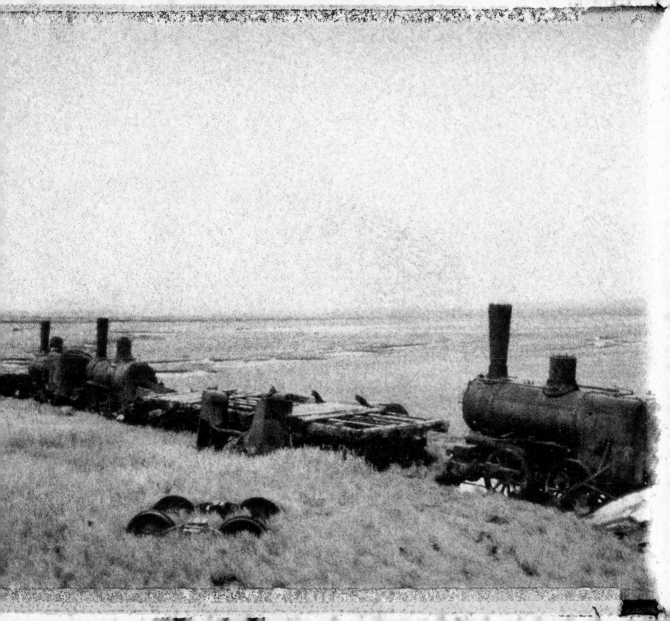

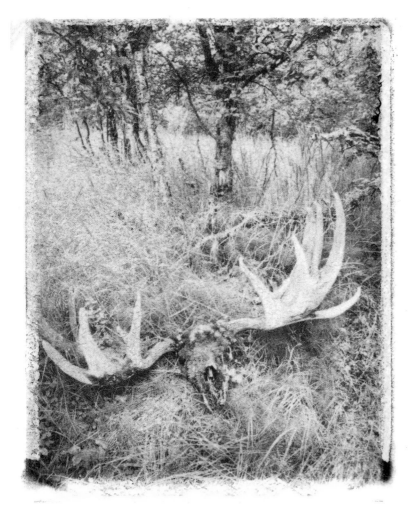

◄◄ Near the old gold-mining town of Solomon, outside of Nome, steam locomotives rust on the tundra. The engines arrived just as the gold boom went bust.

◄ Moss-covered moose antlers greet hikers on a path in Katmai National Park.

Reindeer roam the snowy tundra looking for food. Introduced from Siberia just before the 20th century, the animals are raised in Alaska for food and clothing.

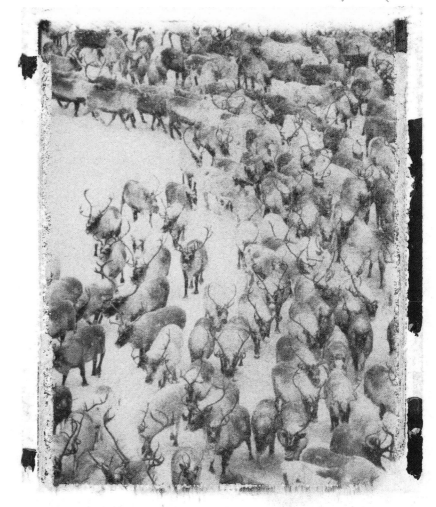

Land

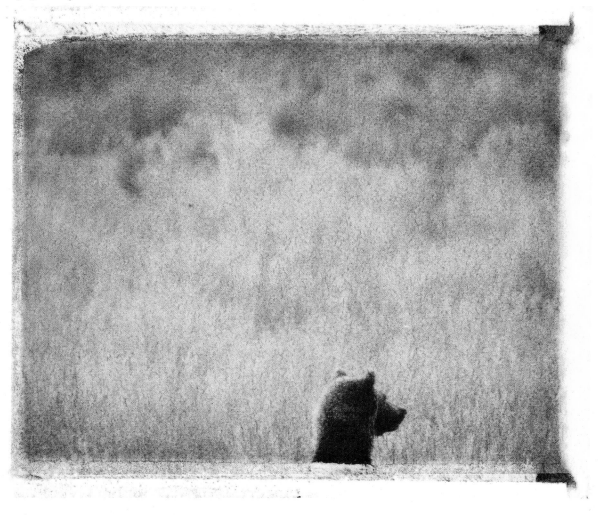

◄ A brown bear scans the tall grass for other bears at Brooks River in Katmai National Park. Normally solitary and territorial, bears migrate each summer to the streams of the Alaska Peninsula to feast on the returning salmon.

▼ A red fox kit yawns on Round Island. Here there are no predators, no hunters, and the bird rookeries offer plenty of eggs and chicks to eat.

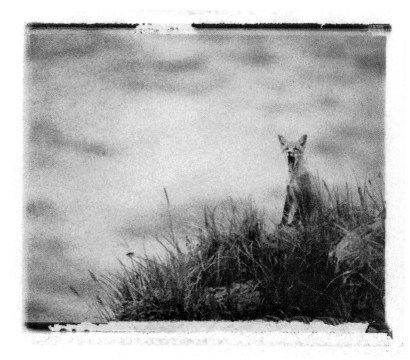

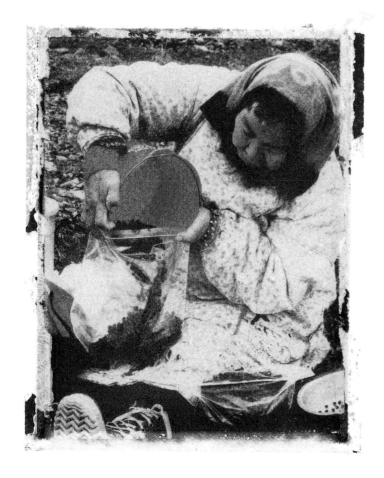

Wearing traditional garb, Inupiat elder Kiadeha Rock empties her bucket full of berries. She will gather berries to freeze and use throughout the winter for many recipes, including "Eskimo ice cream" — whipped marrow, blubber, sugar, and berries.

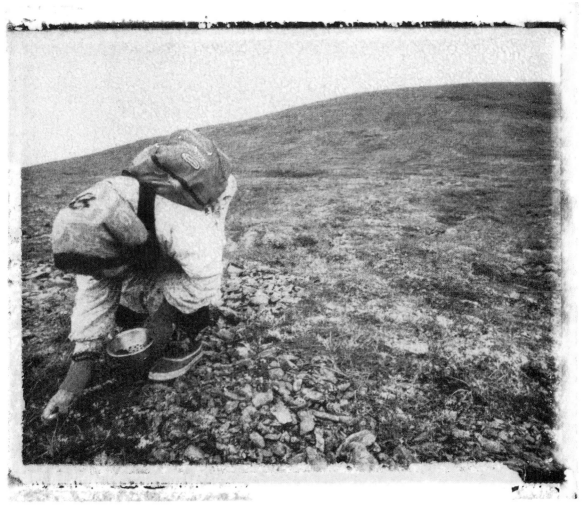

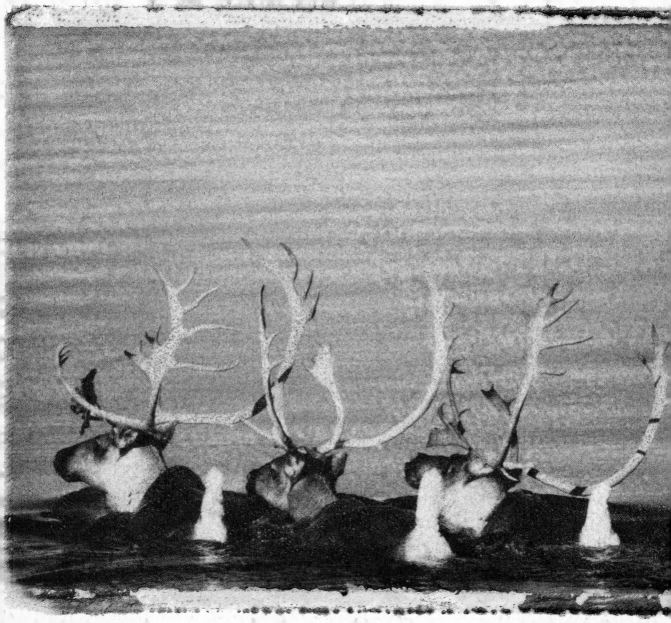

◄ Caribou swim across the Kobuk River near Ambler during their annual fall migration.

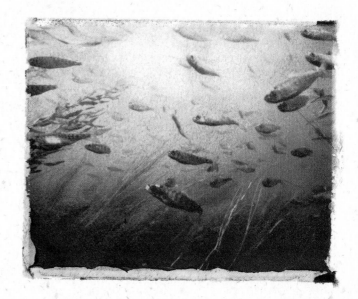

▲ Migrating sockeye smolts are pushed to the ocean by the powerful currents of the Naknek River.

Rivers

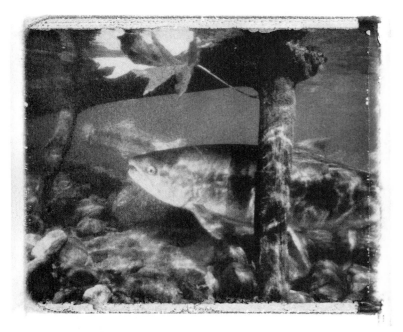

▲ A female spawning salmon swims beneath the surface of a stream. As the trees lose their leaves, these salmon finish their lives.

▸ Heroes of the natural world and stars of an ages-old drama, the saga of salmon is one of wonder and mystery. With its humpback and pronounced jaw harkening back to its prehistoric roots, this sockeye salmon is ready to spawn in an Alaska Peninsula river.

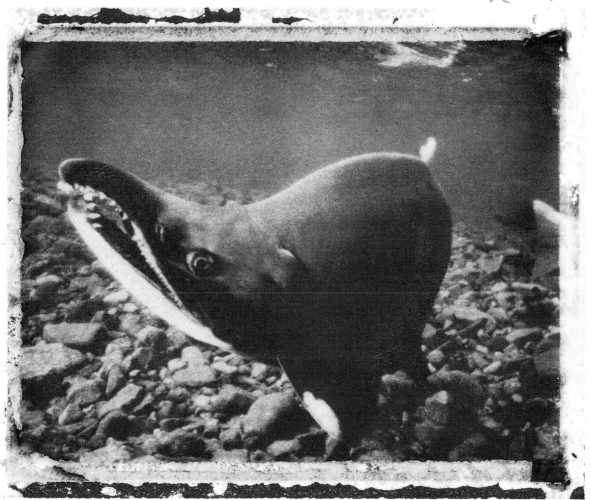

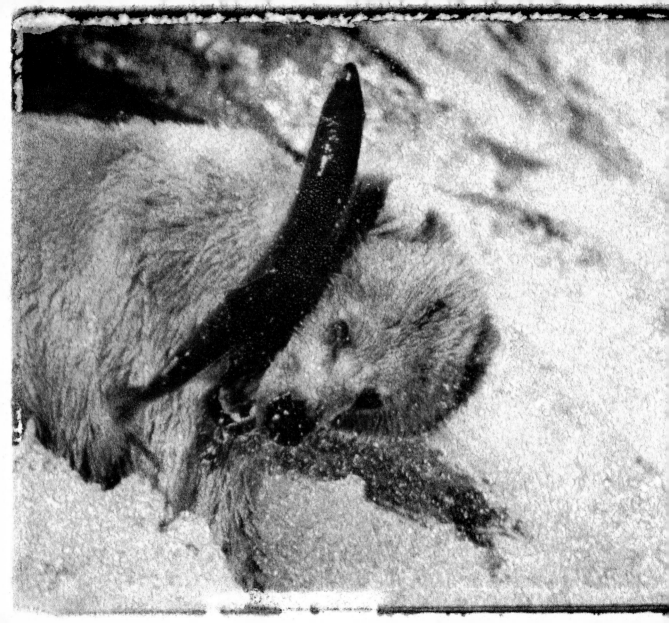

◄ A brown bear tries in vain to snatch a leaping sockeye salmon on a river on the Alaska Peninsula. Coastal bears can reach up to 1500 pounds by dining on the oil-rich fish.

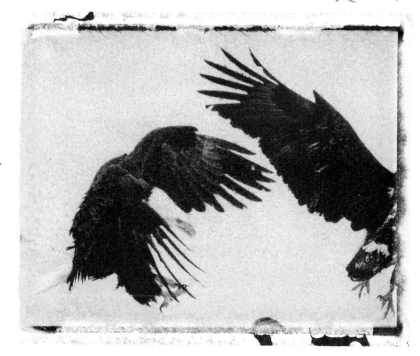

▲ Two bald eagles fight over a piece of salmon at the Chilkat Bald Eagle Preserve near Haines, Alaska. Each year over 5000 eagles congregate to feast on a late run of chum salmon.

73

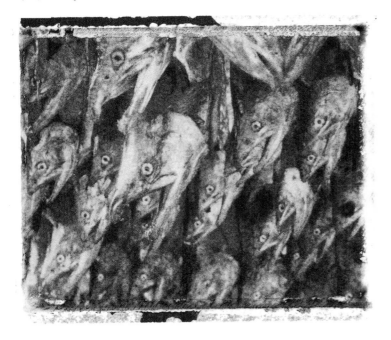

► Cathy Fliris hangs salmon to dry at her fish camp on the Yukon River near Tanana. Her family will survive on the salmon she puts up during the summer.

▲ At a fish camp on the Yukon River, hundreds of miles from the ocean, chum salmon dry on a wooden rack.

Land

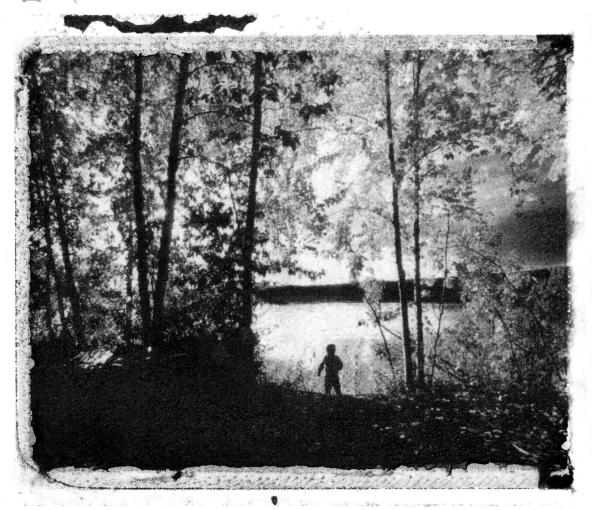

◄ At this Yukon River fish camp, when the leaves turn autumn gold in September, people know that winter is not far behind.

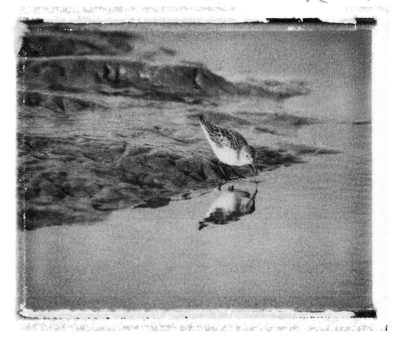

▲ A least sandpiper sips water from a slough on the Yukon-Kuskokwim Delta.

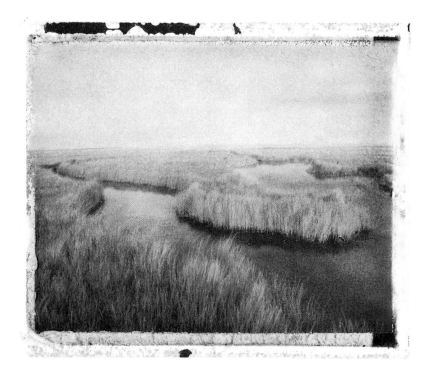

▲ The Yukon-Kuskokwim Delta is pockmarked with tundra ponds that make it a major rearing area for waterfowl and the "Alaska state bird," the mosquito.

▶ At the village site of old Chevak on the Yukon-Kuskokwim Delta, a youngster waits for his parents to finish fishing. After the U.S. government moved the Native village, the only remnants are half of the church and its cemetery.

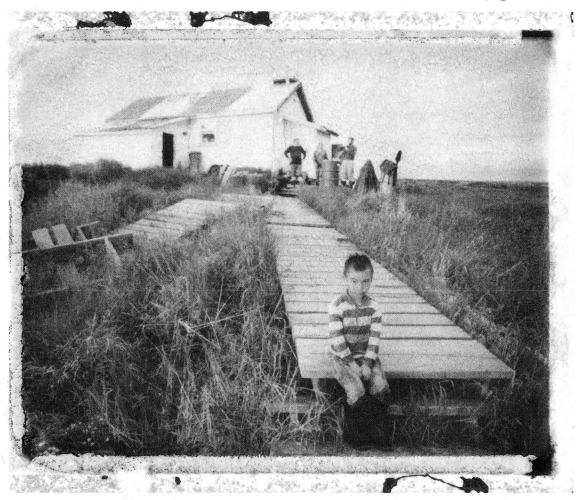

Land

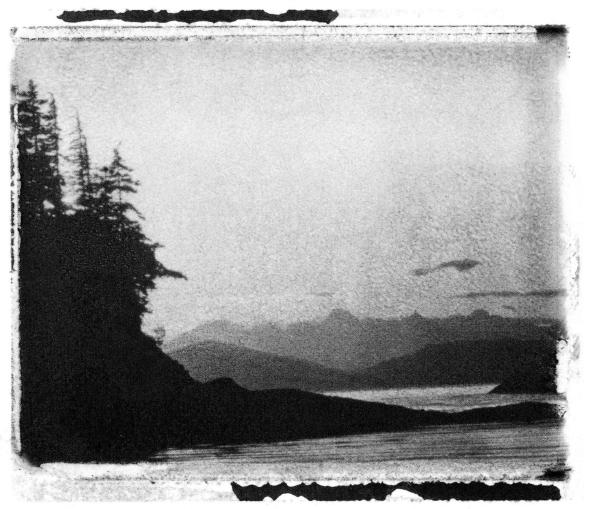

80

▼ Fog lies thick over the cool waters of the Bering Sea. It can be challenged by the wind but stays intact to shroud the sun.

◄ A myriad of streams enter the bays of Prince William Sound.

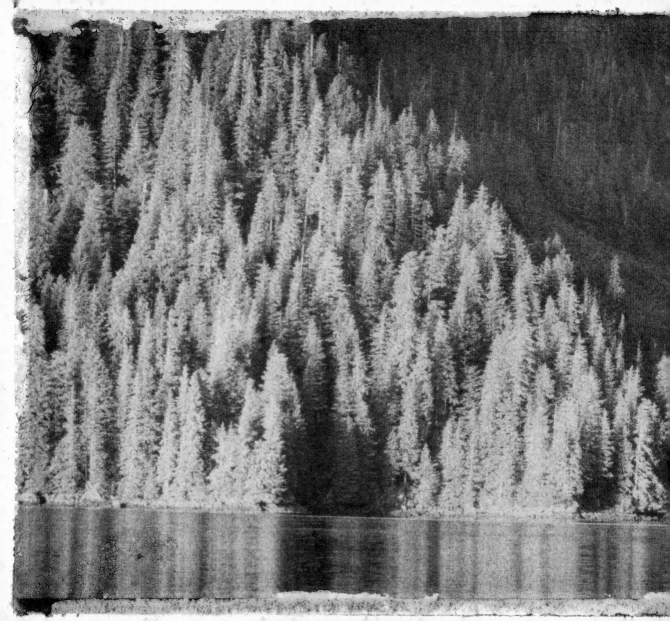

◀ Plentiful rainfall and fertile soil create the thick old-growth forests of Southeast Alaska.

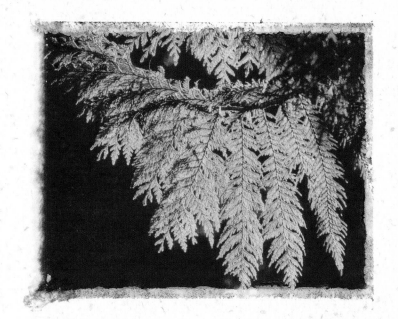

▲ The sun highlights a western red cedar branch.

Forests

A brown bear pauses after lunching on salmon at the edge of the woods. A myriad of wildlife finds haven in the forests of Southeast Alaska.

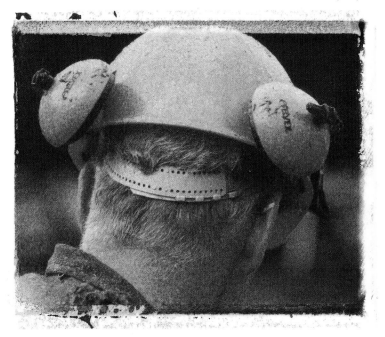

Slim Huckeby takes a break. Hard hats and ear protectors are important safety equipment items for loggers.

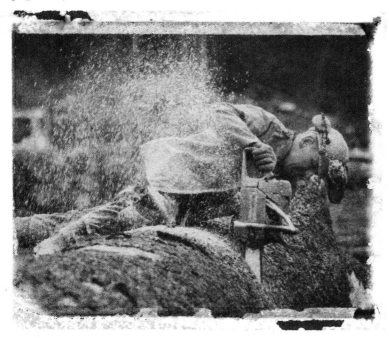

▶ Spruce, hemlock, and cedar are cabled together before being exported to Asia.

▲ Slim Huckeby "bumps" knots off of logs at a Sealaska Native Corporation sorting yard in the Tongass National Forest. Although careful, he says, "I've left a piece of me in almost every forest around here."

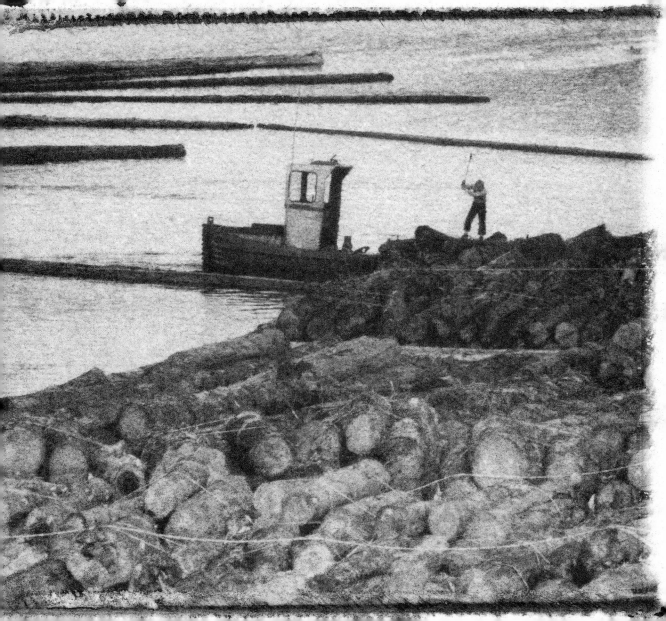

Land

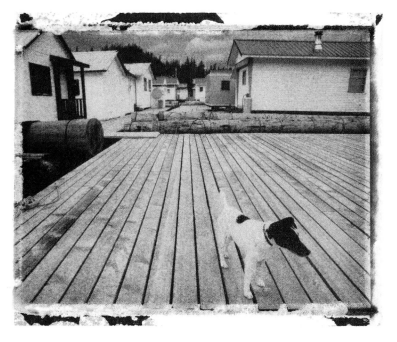

▲ A dog patrols the floats of the Gildersleeve logging camp in Southeast Alaska. By operating one of the few family camps left in Alaska, Keaton and Colleen Gildersleeve continue the logging tradition begun by his grandparents.

▶ With hours of cutting logs behind them, and hours to go before they head back to camp, loggers Slim Huckeby and Gary Thill take a short break. Loggers routinely work twelve or more hours a day.

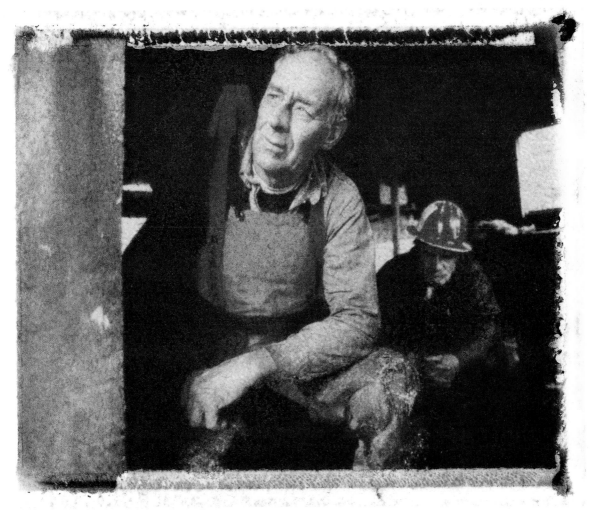

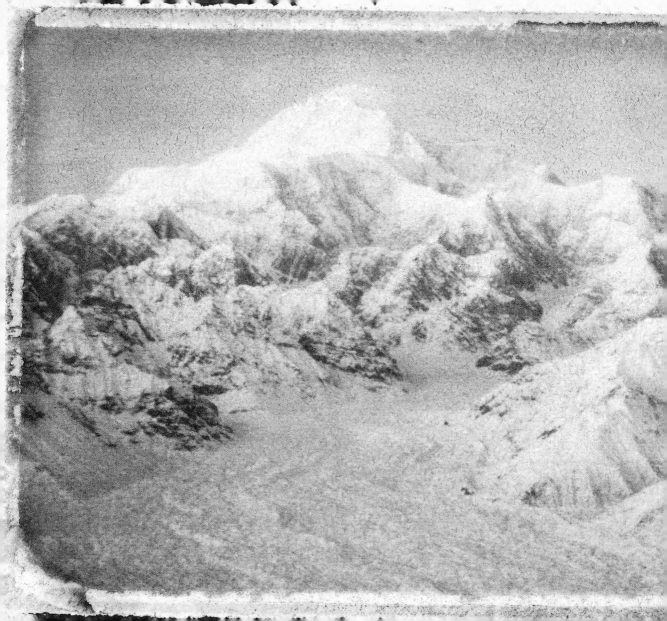

◄ At 20,320 feet, Mount McKinley is the highest peak in North America. Alaskans often call the majestic mountain Denali, an Athabascan word meaning "the great one."

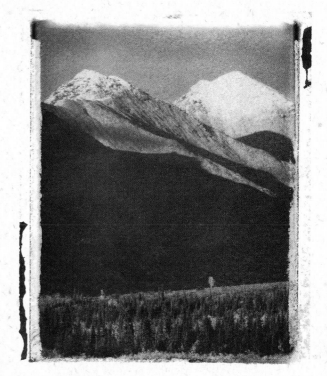

Mountains

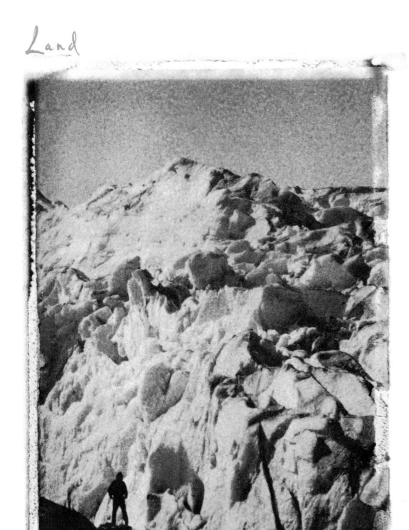

◄◄ Dusted with the first snow of the season, the Jade Mountains rise near the Kobuk River.

◄ Scott Sunde is dwarfed by the ice face of Reid Glacier in Glacier Bay National Park. More than a quarter-million people visit the park each year.

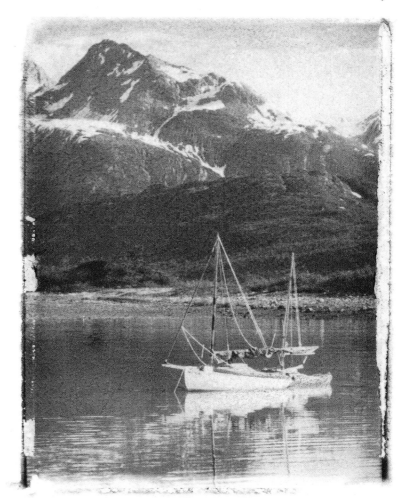

Calm waters reflect a small sailboat anchored in Glacier Bay's Reid Inlet. A mecca for kayakers, boaters, and cruise lines, the park has developed a permit system to prevent overcrowding.

Land

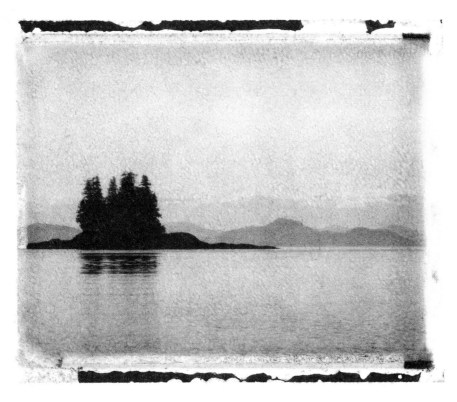

▶ Boaters enjoy a skiff ride as Prince William Sound glows with the setting sun.

▲ The multilayered beauty of Prince William Sound begins with island reflections and ends with a backdrop of mountains.

Mountains

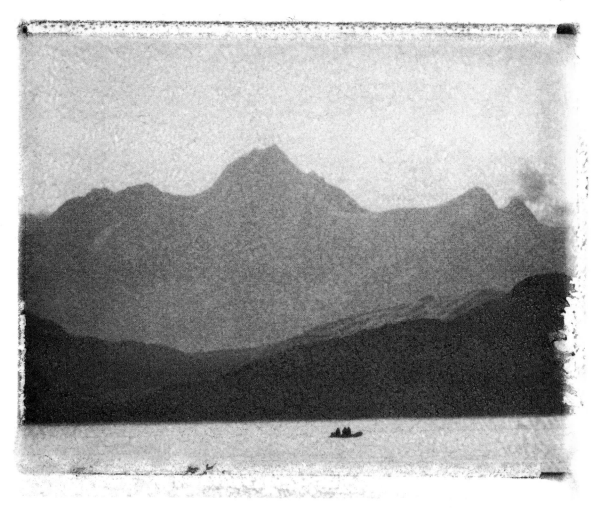

95

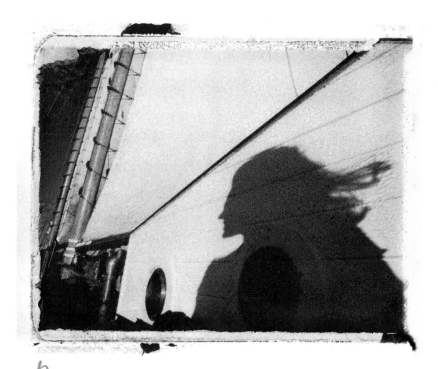

*N*atalie Fobes is an author and the photographer of the award-winning book, *Reaching Home: Pacific Salmon, Pacific People*. Her work is published in *National Geographic, Audubon, Smithsonian, Forbes, Geo, Travel Holiday,* and other magazines. A Pulitzer Prize finalist, Natalie specializes in photographing and writing about the relationships between people and the environment. She makes her home in Seattle, Washington, with her husband.